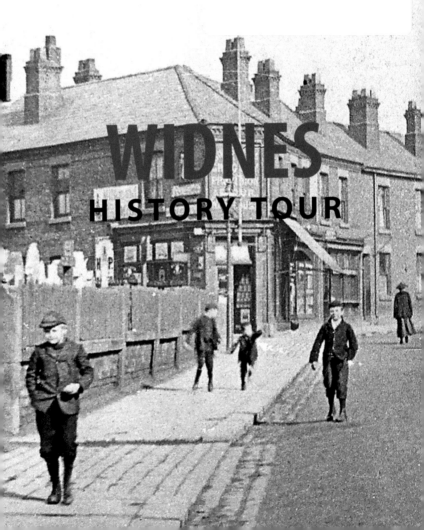

WIDNES

HISTORY TOUR

First published 2018

Amberley Publishing
The Hill, Stroud,
Gloucestershire, GL5 4EP
www.amberley-books.com

Copyright © Jean & John Bradburn, 2018
Map contains Ordnance Survey data
© Crown copyright and database
right [2018]

The right of Jean & John Bradburn
to be identified as the Authors
of this work has been asserted in
accordance with the Copyrights,
Designs and Patents Act 1988.

ISBN 978 1 4456 7857 3 (print)
ISBN 978 1 4456 7858 0 (ebook)

British Library Cataloguing in
Publication Data.
A catalogue record for this book is
available from the British Library.

Origination by Amberley Publishing.
Printed in Great Britain.

INTRODUCTION

We start our walk in the oldest part of the town that we now know as Widnes. Originally Farnworth was the principal village in the medieval period, and it is believed the name derives from the word fearn and farm or estate.

The church was Saxon in origin and dedicated to St Wilfred. It was developed by the Normans, who added the fourteenth-century tower. Originally it was a chapel of ease known as St Wilfred's in the parish of Prescot. It was rededicated to St Luke in 1859. This church is a splendid memorial to the Bold family and their generosity to the people of Farnworth. Do try to see inside this wonderful church if you can.

Legend says that a local blacksmith named Bold killed a griffin that had been terrorising the village. The blacksmith went on to become the local lord and the griffin was incorporated into the family coat of arms. The legend is portrayed in a glass panel in the Ring O'Bells.

Farnworth can claim some notable residents: Bishop William Smyth (1460–1514), who was co-founder of Brasenose College, Oxford, and Richard Bancroft (1544–1610), who became the Archbishop of Canterbury and Chief Overseer of the Bible, a task that allowed the holy book to be printed and become a text that could be read by the masses. Another famous resident is Roy Chadwick (1893–1947), who was born at Marsh Hall and was the designer of magnificent aircraft, including the Lancaster and Vulcan Bombers.

The village of Appleton derives its name from apple town. Although most of its old halls and the dilapidated houses have been

swept away, it still retains its unique village charm. Its charm was not missed by many of the chemical manufacturers who made their home in the village including John McClelland, Henry Wade Deacon and John Hutchinson.

As we arrive in Victoria Square we can see the fine red-brick Civic Centre. As the town entered the Victorian age the civic dignitaries were keen to design buildings that would compete in splendour with other towns and cities. The fine town hall was built in 1887 in a style described as 'French Renaissance'. In 1895 the new technical school and library were built. Even the bus garage was built in style with splendid terracotta mouldings.

We then travel down Victoria Road towards West Bank. This area was transformed from a sleepy community on the banks of the River Mersey into a major industrial centre. In the 1820s the area was popular with day trippers who would enjoy the river and views across the estuary.

The building of the Sankey Navigation and John Hutchinson's arrival in 1847 was to dramatically change Spike Island. Other men followed his lead including William Gossage, the Muspratt family, Henry Deacon and John McClelland. Cheap land, a good water supply and access to the canal and the railway led to the development of Widnes as a major industrial centre. Factories were built, back-to-back dwellings were provided for the workers and the area became black with fumes.

As we look at Spike Island now we can see the Catalyst Museum, which is once again a green and pleasant estuary. The estuary is a birdwatchers' paradise. Lapwing, teals, skylarks, Canada geese and swallows can all be seen at different times of the year. The canal locks have been restored and the area is a pleasant place to stroll.

KEY

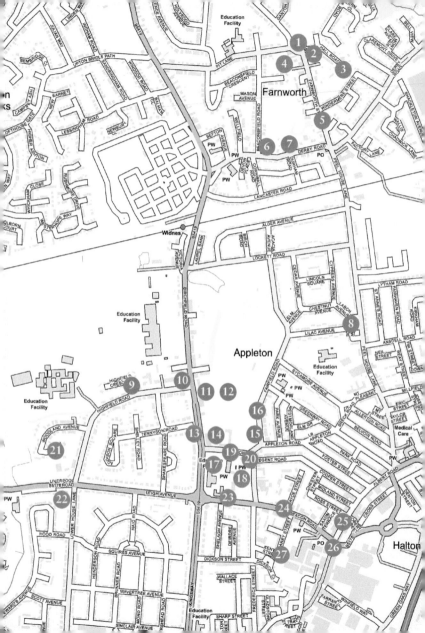

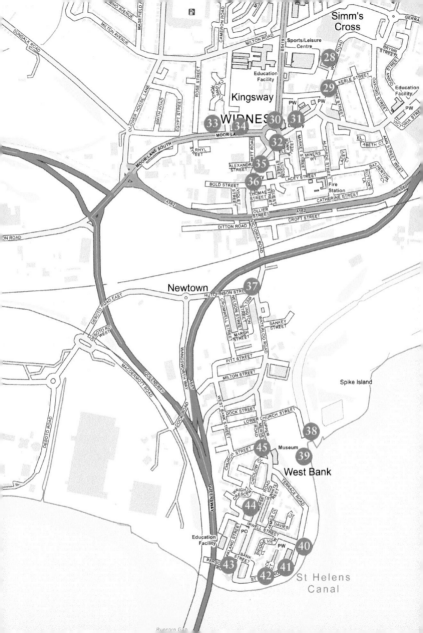

1. FARNWORTH CHURCH AND THE SITE OF THE OLD GRAMMAR SCHOOL

Originally a chapel of ease known as St Wilfred's in the parish of Prescot, Farnworth Church was rededicated to St Luke in 1859. This fine church is a memorial to the Bold family and their generosity to the people of Farnworth. To the right of the church is the site of the Old Farnworth Grammar School at the top of Farnworth Street. William Smyth, Bishop of Lincoln, endowed the school. Daniel Lea purchased the site in 1860 for £30 and turned it into a successful painting and decorating business. Today we see the corner with the church and the village shop.

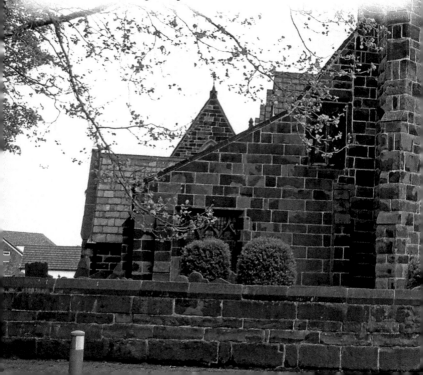

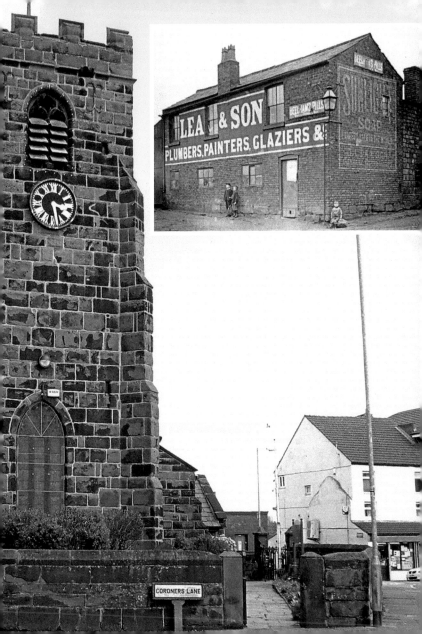

LEA & SON

BEECHAM'S PILLS

PLUMBERS, PAINTERS, GLAZIERS &

SUNLIGHT SOAP

CORONERS LANE

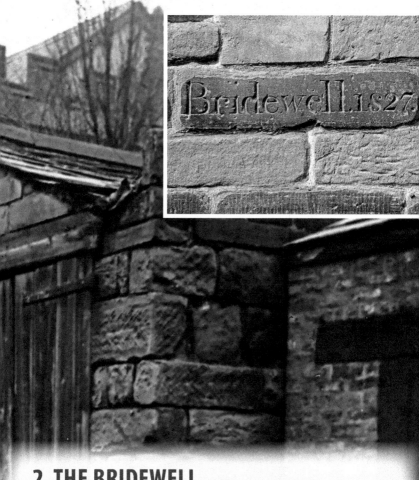

2. THE BRIDEWELL

The lockup of the village was built in 1827 to replace an earlier structure. They were built so that the police could hold offenders until they came up before a magistrate. Many a drunken man spent the night here. It fell into disrepair but was restored in 2000 and now provides an interesting meeting place and a useful contribution to church life.

3. MARSH HALL PAD

This path was important to gain access to the church at the time of the plague. It was purchased by Bishop Smyth for his tenants from Cuerdley to worship at the church without passing through Farnworth village. The old Sunday school is here and close by is the site of the notorious bear-baiting that was once a feature of village life before this cruel sport was banned.

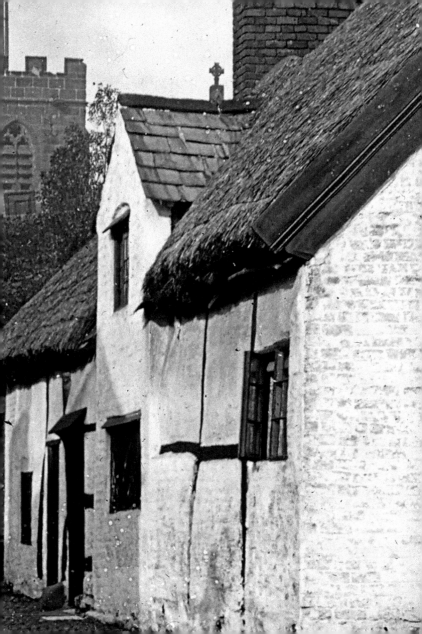

4. THE RING O'BELLS

This pub has been greatly altered over the years. This picture shows the pub around 1890. Originally it was a farmhouse pub and when John Clare was the licensee he was in trouble for serving beer to non-travellers – it was only legal to serve people who lived over 3 miles away. Sadly, he enjoyed his own beer so much that he was often drunk and ended up bankrupt.

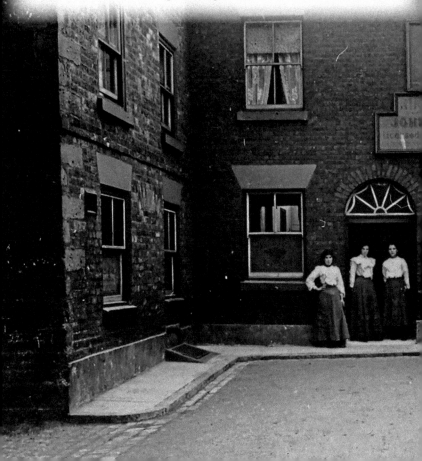

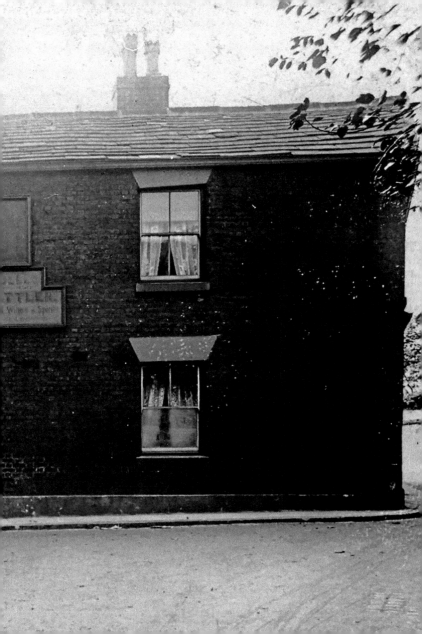

5. CHURCH STREET (NOW FARNWORTH STREET)

Looking up the street around 1905, the tall building on the left, with the bay window, was Kirkham's bakery. Nearby, there was a busy sailcloth factory, a thriving industry of the time. Boatbuilding was an important local industry.

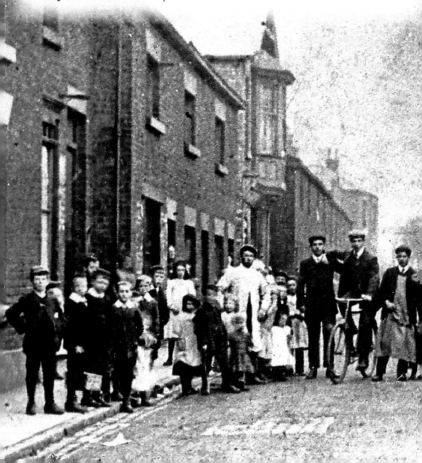

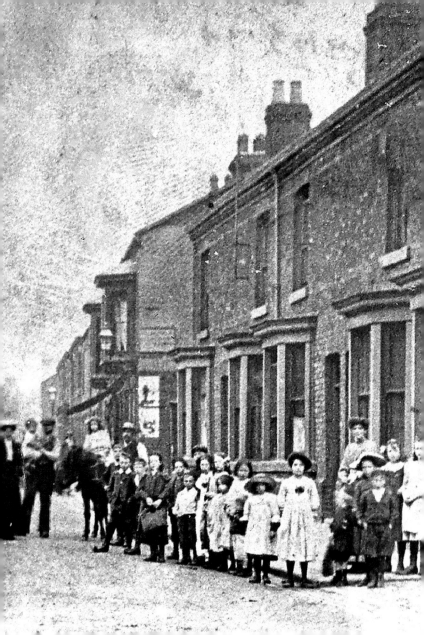

6. FARNWORTH GRAMMAR SCHOOL

This site on the corner of Derby Road and Beaconsfield Road was the Intermediate Grammar School. Mr James Raven was appointed headmaster in 1861, a fine teacher who paid for the required fittings from his own pocket. He was popular in the area, restored the reputation of the school and even built an extension to house boarders.

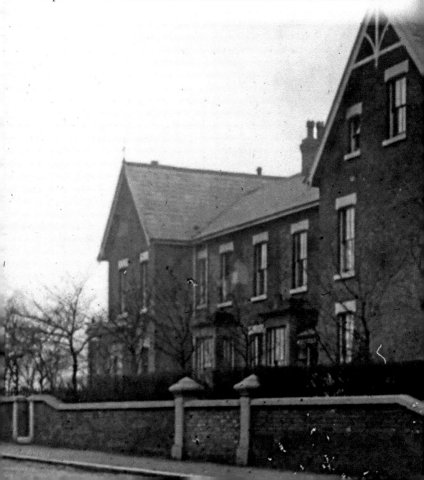

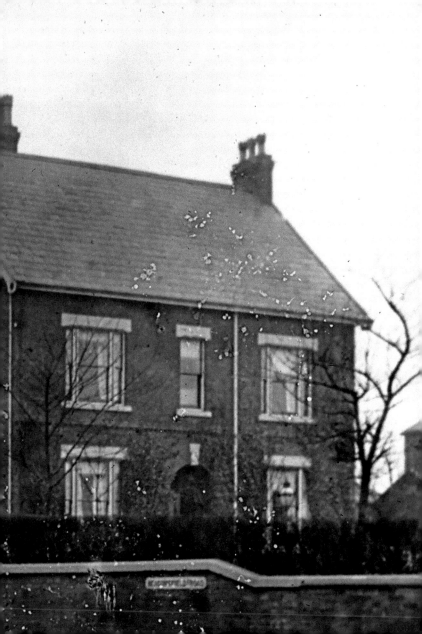

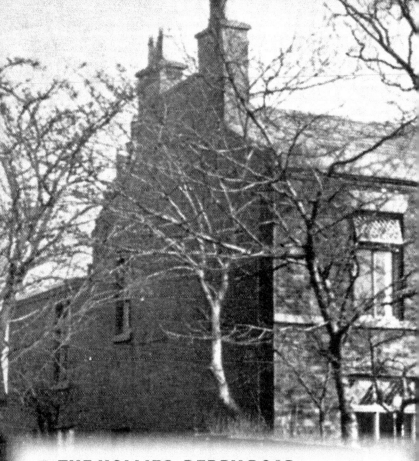

7. THE HOLLIES, DERBY ROAD

This was the home of Ludwig Mond. When he first worked at Hutchinson's he lodged at the Mersey Hotel, but after his marriage to Frida Lowenthal he returned to Widnes to make it their home. In August 1867 they moved into The Hollies on Derby Road. In October 1868 the family rejoiced at the birth of Alfred Mond (the future Lord Melchett of ICI fame).

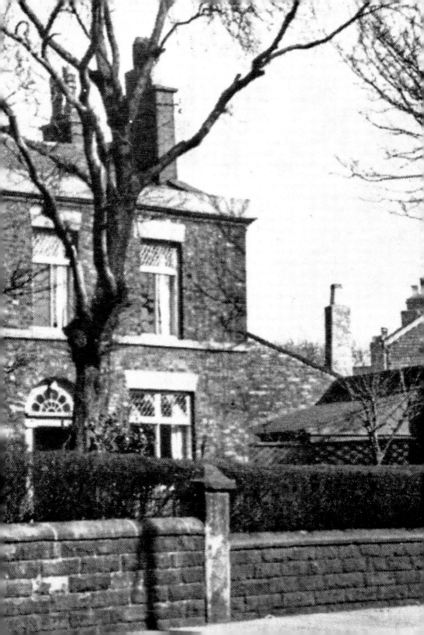

8. PEEL HOUSE

Peel House was the home of William Smyth, who founded Farnworth Grammar School. He was also a co-founder of Brasenose College Oxford. He was a wealthy man who also founded a chapel at Farnworth Church. A company was established in 1890 to develop a housing estate, and Peel House was demolished. The hall was situated by the attractive green space by Lilac Avenue.

NICHOLSON.

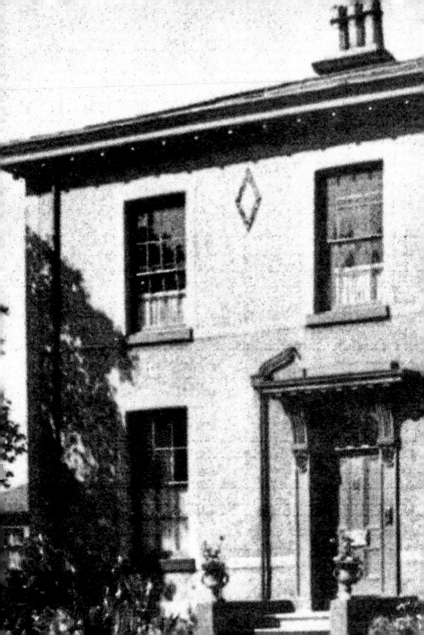

9. HIGHFIELD HOUSE

Highfield House was built by John McClelland, a local industrialist who came to Widnes in 1846. He founded the North British Chemical Co., manufacturing borax and alkali. This grand house became a maternity hospital and holds many happy memories. It is still a NHS clinic today.

10. CATHOLIC ACADEMY

The Catholic Academy was built in 1830 in Highfield Road. It was a boarding school that catered for students from all over the world. Appleton was a stronghold of Catholicism at the time. This fine terrace has survived and is now known as Appleton Villas.

SEARS BROS 40 DUKE ST

Catholic

APPLETON IN WIDNES, near

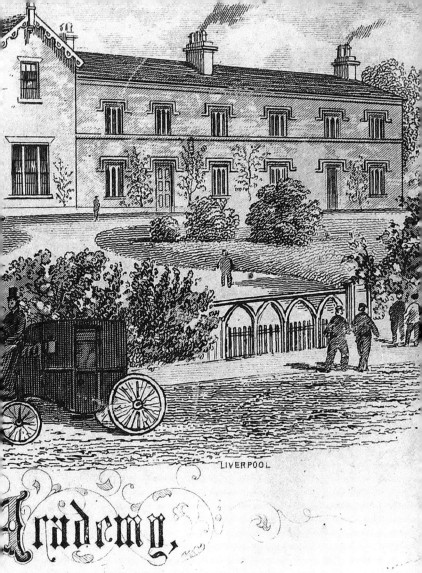

LIVERPOOL

Academy,
WARRINGTON.

11. VICTORIA PARK GATES, APPLETON

Here we see two elegantly dressed young men by the exquisite wrought-iron gates of Victoria Park. The park was opened in 1900 as a memorial to Queen Victoria's Diamond Jubilee celebration of 1897. We see the Gladstone fountain in the background. The park was a favourite spot to stroll to show off the fashions of the day.

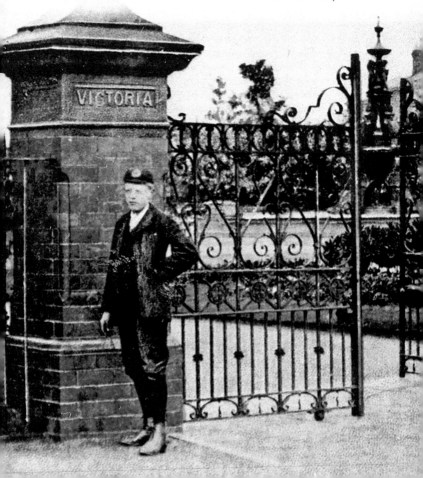

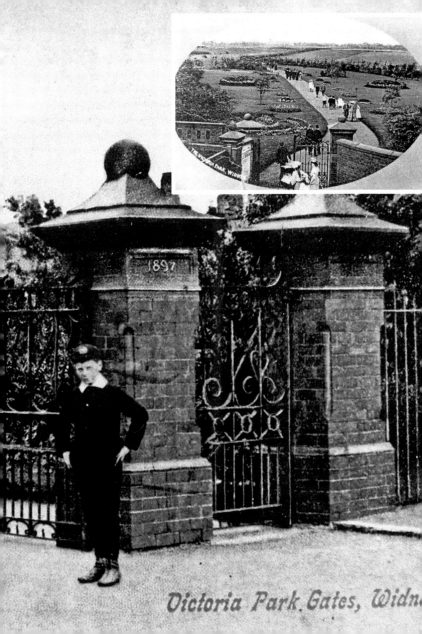

Victoria Park Gates, Widn

12. GLADSTONE MEMORIAL, VICTORIA PARK, APPLETON

The Gladstone fountain was officially opened in May 1903. In 1913 George V visited the park to see the statue. The war memorial lists the name of 818 brave local men who lost their lives in the First World War. This included Thomas Mottershead of the Royal Flying Corps, the first Widnes man to receive the Victoria Cross. His plane was shot and enveloped in flames but he succeeded in bringing the plane safely back behind British lines. Sadly he later died of his injuries.

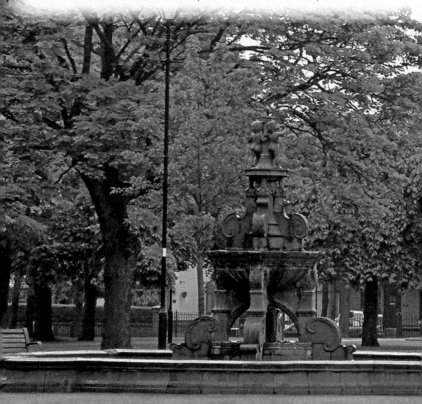

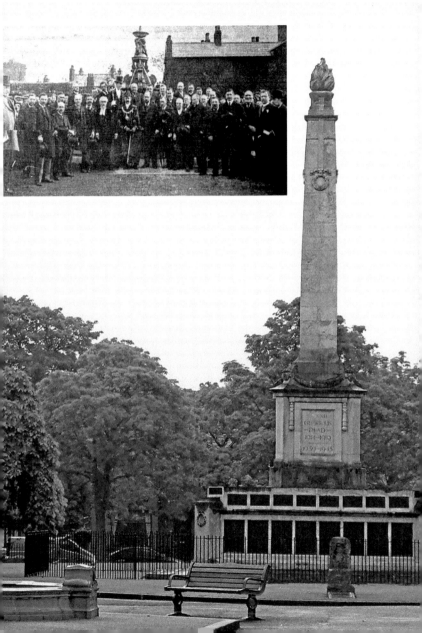

13. BIRCHFIELD ROAD, APPLETON

The Horse & Jockey now stands alone, although here we see it was once part of the terrace. Originally a beerhouse named The Greyhound stood on the site. Happily, the fine terrace with bay windows still stand today. Further up the road we can see Pineapple Terrace, which refers to the family crest of the Appleton family.

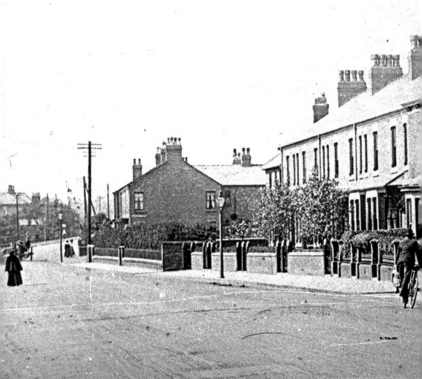

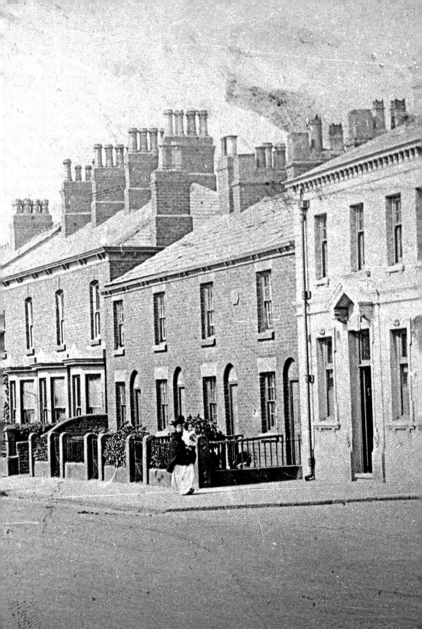

14. APPLETON HALL

Built in the sixteenth century, Appleton Hall was the home of the Hawarden family. The name Appleton is thought to be derived from the many apple orchards around the village. The hall is long gone but it stood at the top of Appleton Village on the site of the Park Insulation Works.

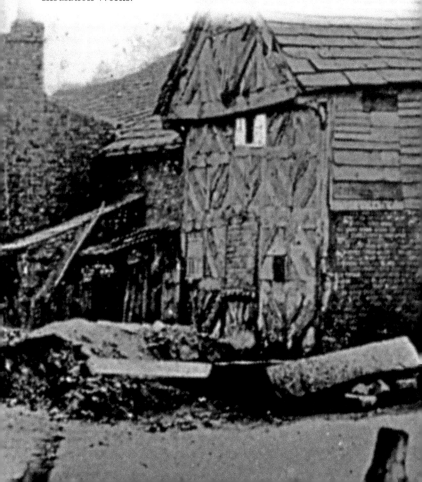

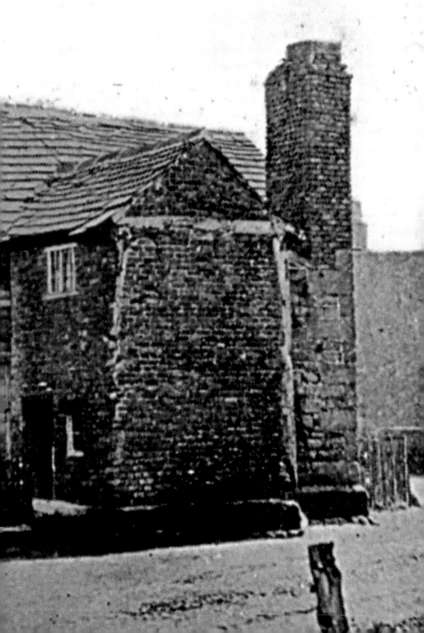

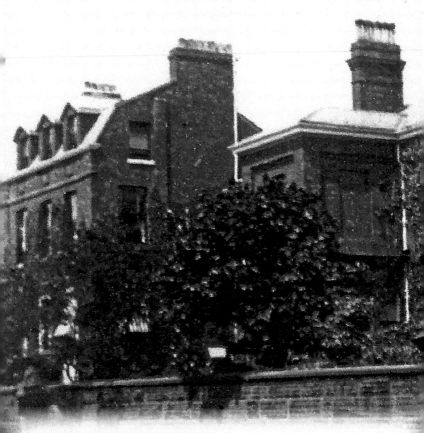

15. APPLETON HOUSE

Appleton House stood where the rose garden is planted in Victoria Park, and was built as the home of Sir Henry Wade Deacon, a name very familiar to Widnesians. He worked with John Hutchinson and later founded Gaskell, Deacon & Co. Between 1854 and 1876 Deacon, alone or in collaboration with others, filed at least twenty-nine patents – all relating to alkali manufacture.

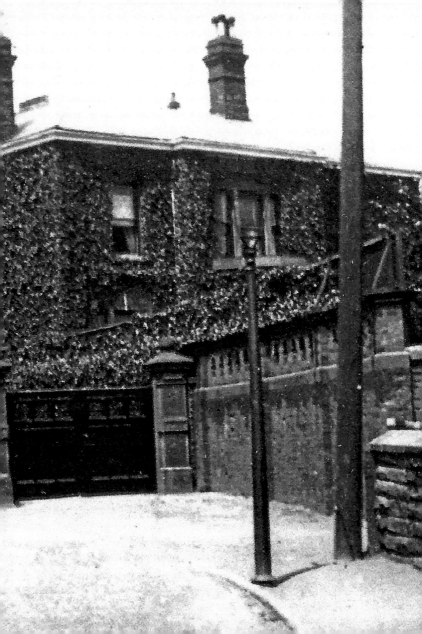

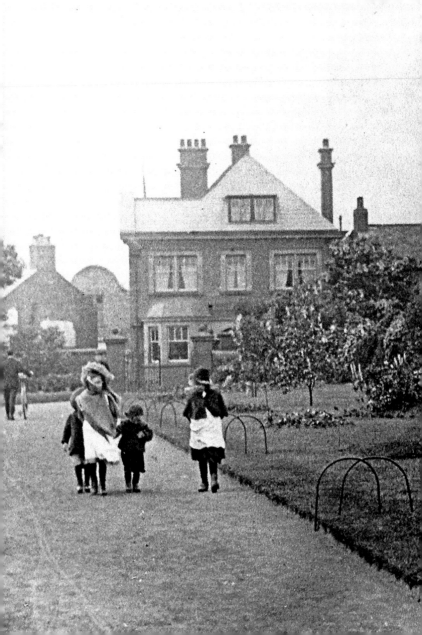

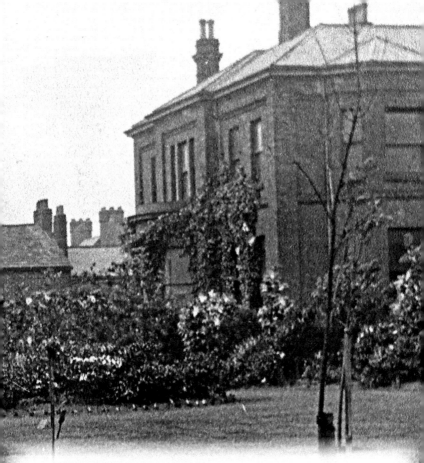

16. APPLETON HOUSE FROM VICTORIA PARK

Again we see Appleton House, this time from the park. The house was demolished in the late 1930s. The estate of Henry Wade Deacon was taken over by Widnes Council in 1876 and was landscaped to be enjoyed by all as a public park in 1900.

17. ENTRANCE TO TITHEBARN STREET

A view from Appleton Village. This was just past St Bede's Church. The 1841 tithe map shows the large numbers living in each dwelling. Tithes were one tenth of all produce payable to the church and the area was named for the large barns needed to hold the produce. Now St Bede's Church is the main feature of the area. The church was built from sandstone supplied by Appleton quarry.

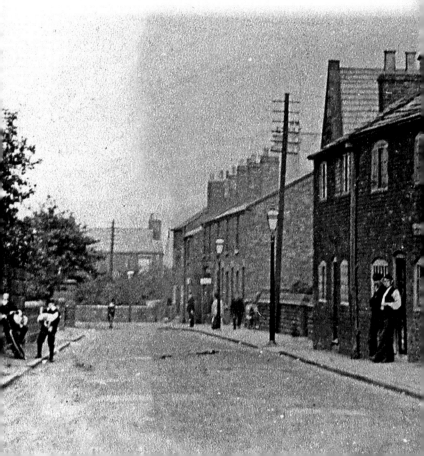

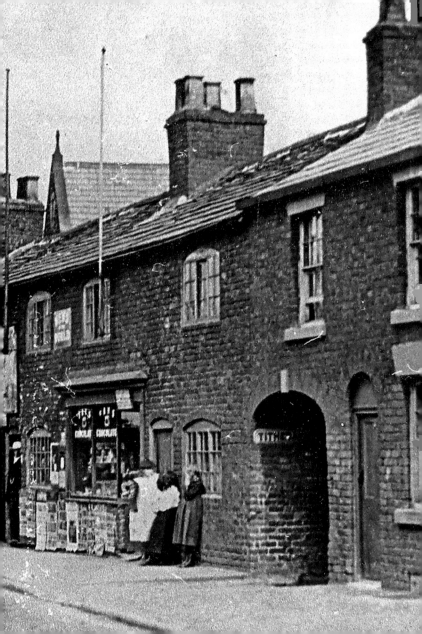

18. TITHEBARN STREET

The Tithebarn Street area was demolished in 1958 but this is a good reminder of the poverty of the time. It is an example of the old-style courts that were overcrowded and unsanitary. This picture shows some distinguished ladies visiting the street and no doubt offering advice to very proud people. Note the washing lines.

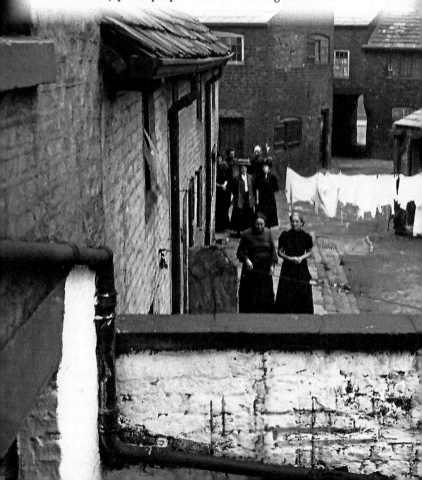

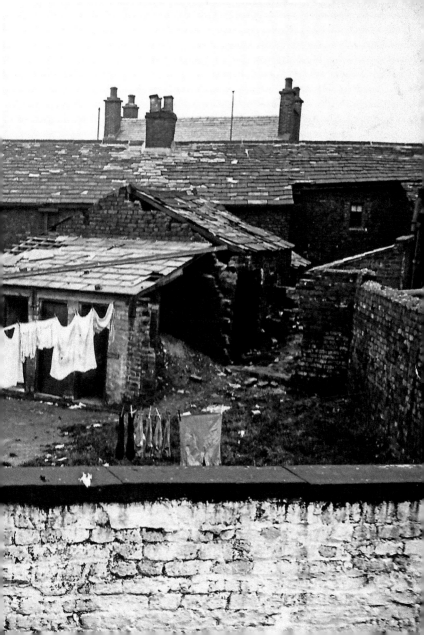

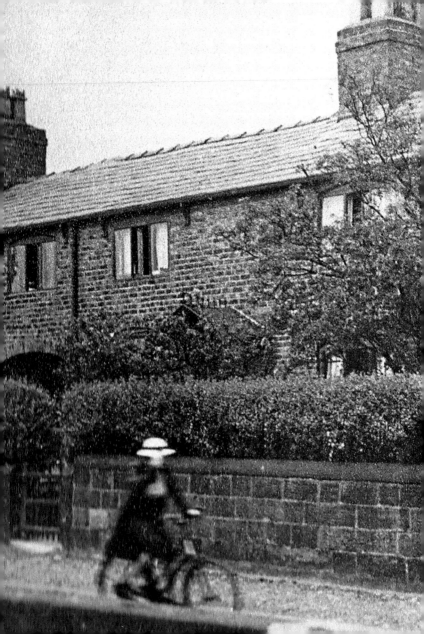

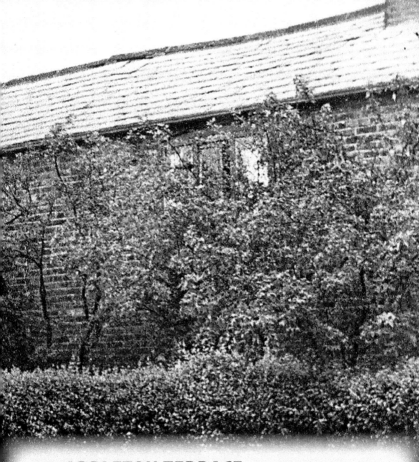

19. APPLETON TERRACE

A row of cottages opposite St Bede's Church that stood on the original Appleton Hall site. These cottages had their own cottage industry – wire drawing – and was the home of the Hayes family. After demolition it was occupied by the Park Insulation Works and has now been redeveloped as new modern apartments.

20. APPLETON LODGE

John Hutchinson opened his first factory in 1847. He built this house for his wife and five children in Appleton, a green and peaceful place to bring up his family, far removed from the smoke and dust of Spike Island. The house was demolished in 1960. It was in Appleton Village, near to the car park and old graveyard.

21. UPPER HOUSE

This superb house was sometimes known as Widnes House. The 1842 tithe shows James Cowley as the owner of the house and estate. The building was demolished in around 1910. Now we see the very green Widnes Golf Club and only the old brewery is still standing. It is now used as a changing room for the golfers.

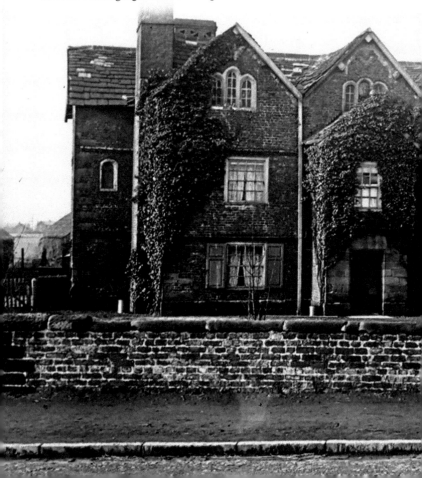

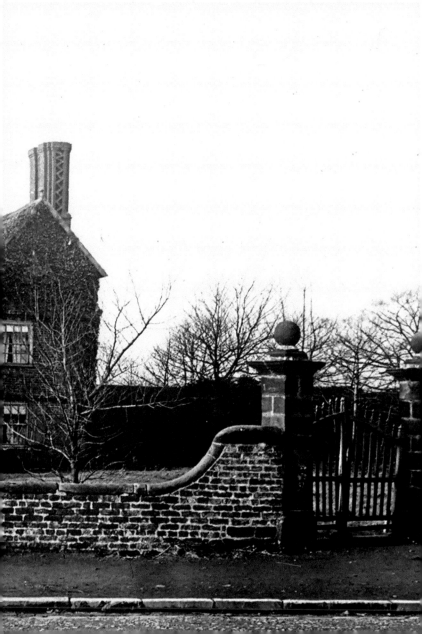

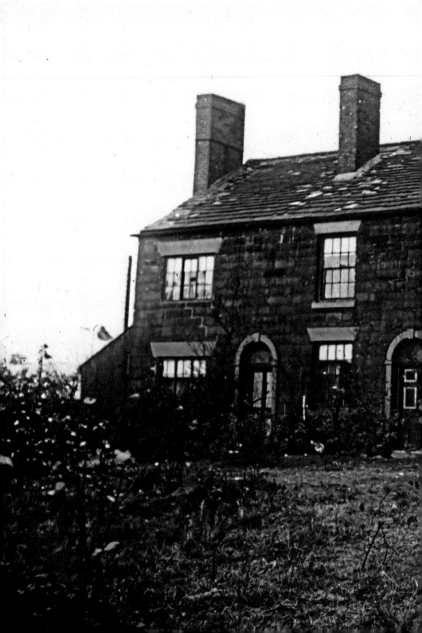

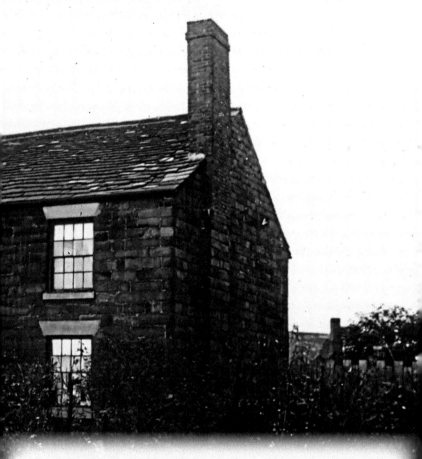

22. LOWER HOUSE

A much simpler affair than Upper House, Lower House was a farmhouse built in the reign of Charles I. The 1842 tithe shows the owner to be John Shaw Leigh and the tenant was Elizabeth Houghton. It was used by Catholics as a meeting place. Eventually St Bede's Roman Catholic Church was built in 1846. Now this corner of Lower House Lane is dominated by The Albion.

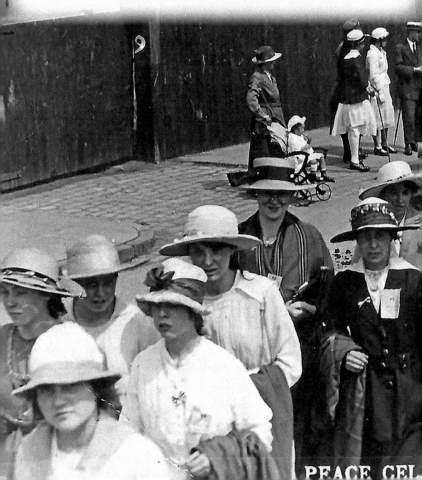

23. PEACE MARCH, DEACON ROAD

In 1919 Widnes celebrated the end of the war. The town, like many others, had lost a generation of men and peace was greeted with huge relief. Here we see the people of the town and the children in their Sunday best in Deacon Road. The photographer must have stood on the corner of Frederick Street.

PEACE CEL

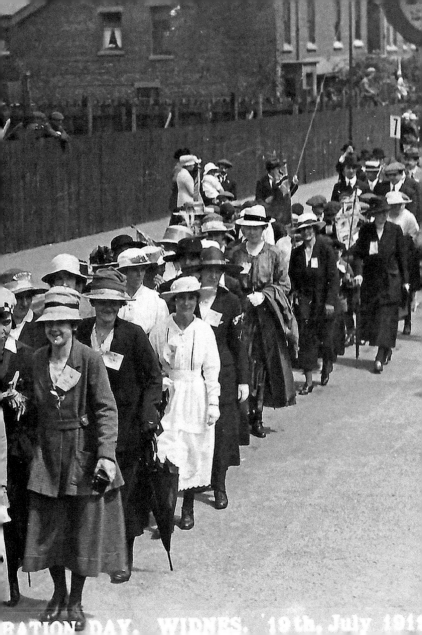

BATION DAY. WIDNES. '19th, July 1911

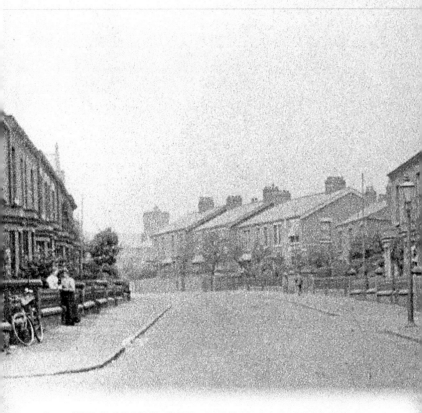

24. DEACON ROAD LOOKING TOWARDS ST BEDE'S CHURCH, 1910

Deacon Road terraces were built in the early 1900s. The road was named after Sir Henry Wade Deacon and was the main thoroughfare at the time. This photo reflects the quiet dignity of the town at this time.

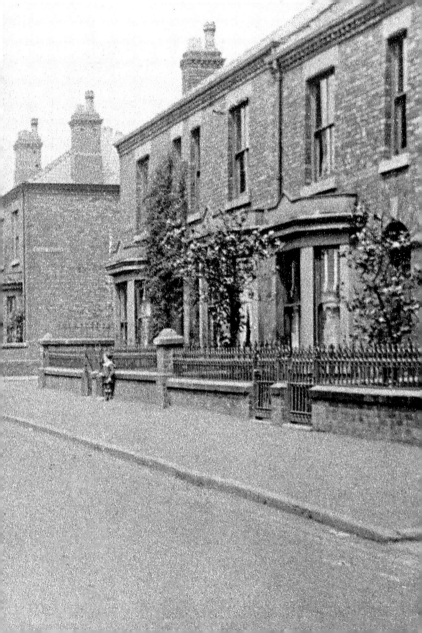

25. ALBERT ROAD FROM DEACON ROAD

On the right of this image is Appleton Villa, and later the Regal Cinema was constructed on the site. Albert Road is now a pedestrianised busy shopping street, and much of this area was cleared to make way for the new market and shopping centre. This is a view towards Peelhouse Lane.

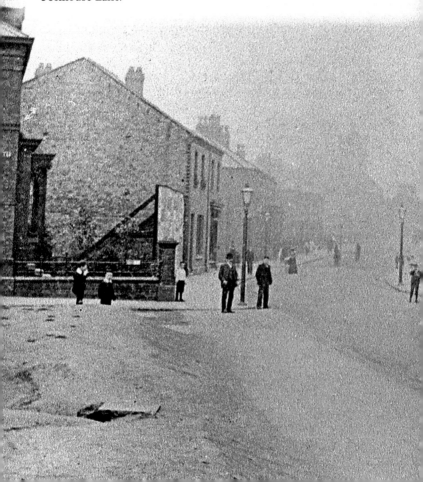

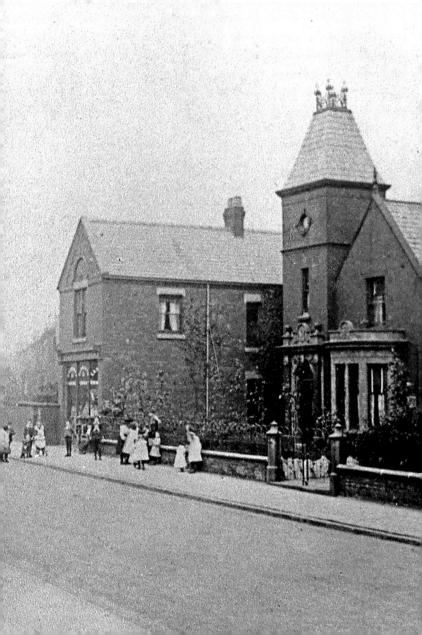

26. ALBERT ROAD

A trolleybus leaving the Bradley Hotel for Prescot around 1908 – it looks rather crowded. This was the main bus route in the town. The Bradley Hotel still stands proudly at the corner of this busy street, filled with shoppers. The buses still run up Albert Road, although it is closed to other traffic.

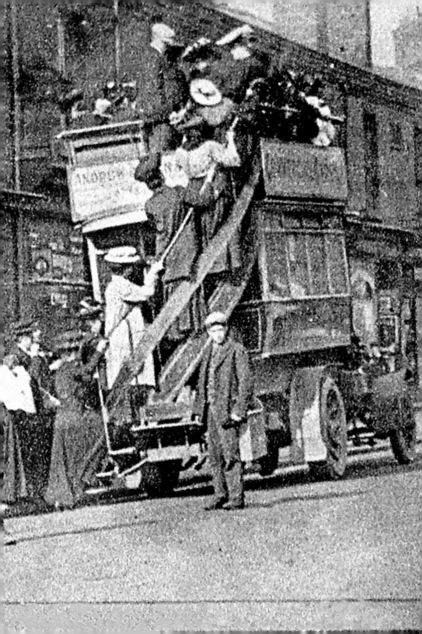

27. THE PRINCE OF WALES, KENT STREET

Here we see the Prince of Wales public house decorated to celebrate the Silver Jubilee of George V in 1935. The pub was commonly known as Reidy's after the publican Billy Reid, who was an ex-Widnes rugby player. Sadly, it is now closed.

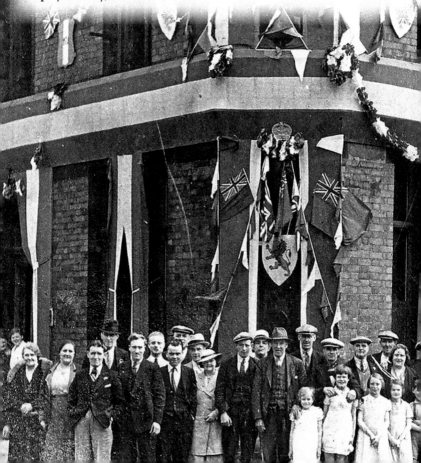

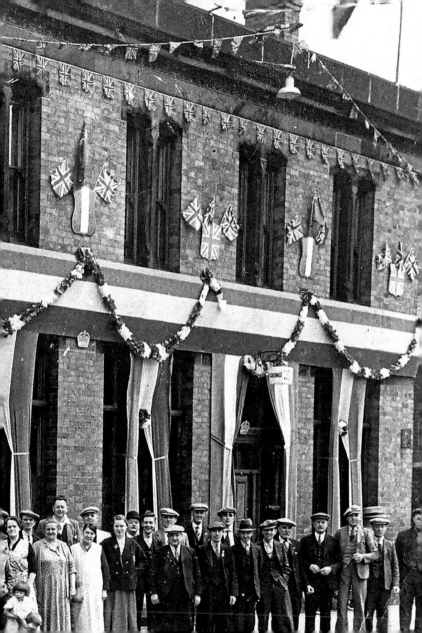

28. SIMMS CROSS

The area takes its name from an ancient cross, which were a common sight around Farnworth and district. What a change from a road full of local shops and no cars to the view today. The old Simms Cross School was here. The primary school is now in Charles Street. The area is now dominated by Asda and its large car park.

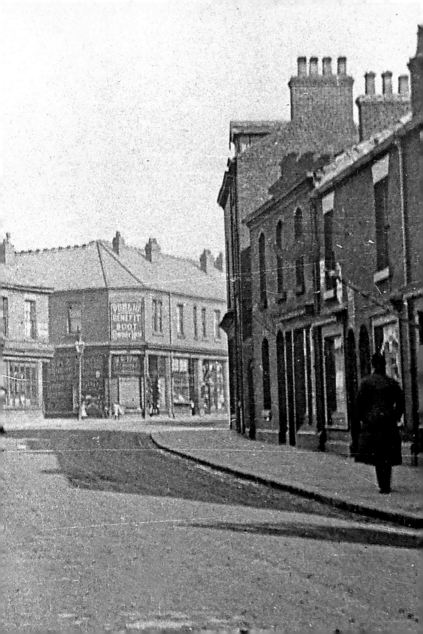

29. VICTORIA SQUARE

A captivating scene in Victoria Square around 1890 celebrating Lifeboat Day. We are looking up Widnes Road towards Simms Cross. There has been a lifeboat on the Mersey since the 1820s and we can see from this image that there was great support for lifeboats in Widnes.

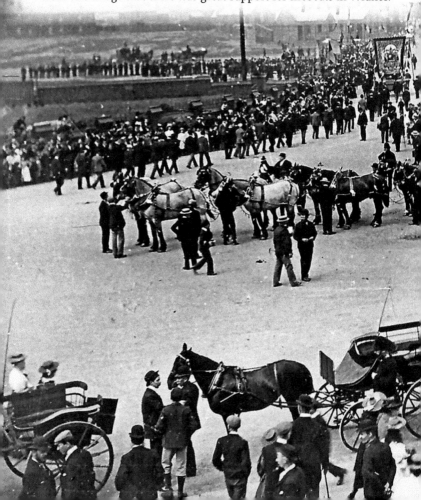

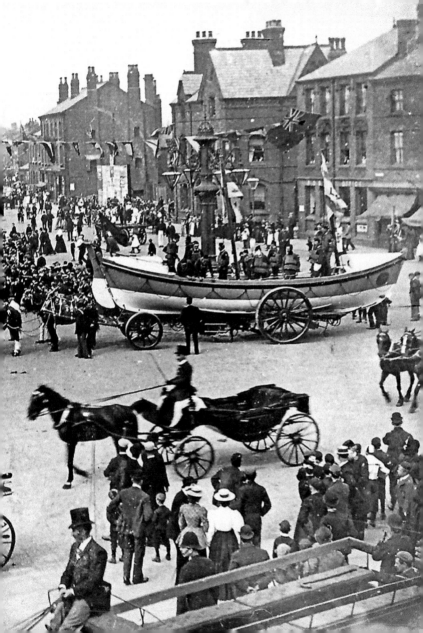

30. WIDNES MUNICIPAL TECHNICAL SCHOOL AND LIBRARY

Widnes was justly proud of its Technical School and Free Public Library. It was opened on 30 July 1896, erected at a cost of over £14,000 and is a structure of red brick and terracotta with a tower. Previously the library had been housed behind the old town hall. Miss Procter the librarian decided to provide open access to the books. Children were not admitted, although boys were allowed to consult the newspapers.

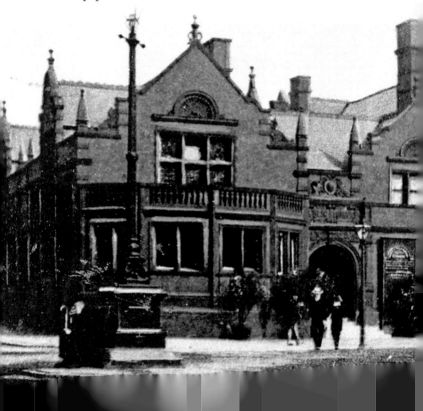

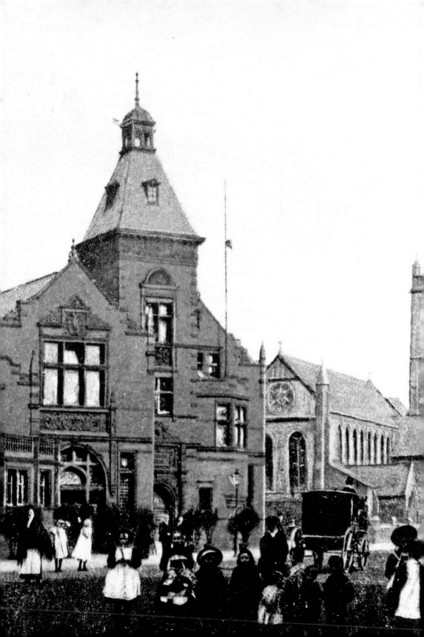

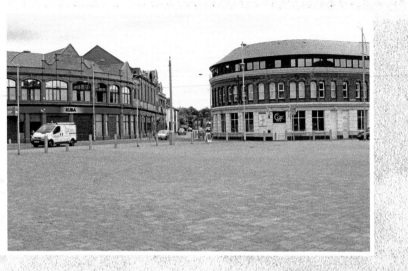

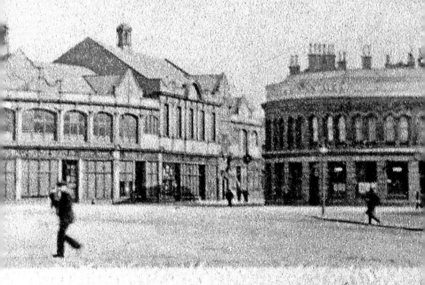

31. VICTORIA SQUARE

This view of the square shows the Co-operative store and the Market Hotel around 1910. The hotel was built to serve the new market hall and the Victorian architecture really enhanced the square.

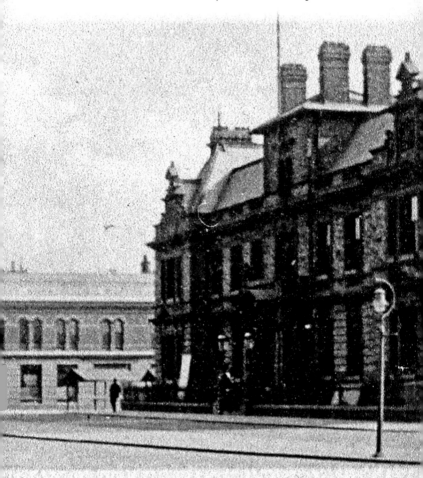

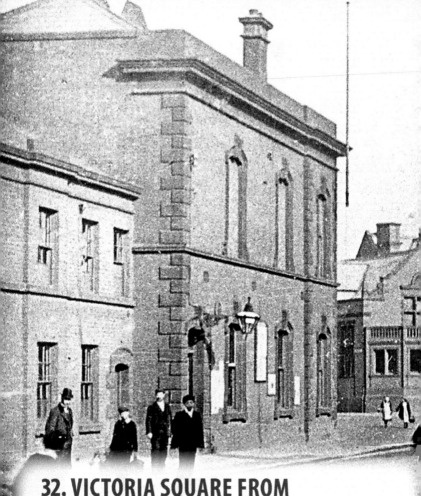

32. VICTORIA SQUARE FROM VICTORIA ROAD

A delightful picture of Victoria Square around 1900. Taken from Victoria Road, it shows the police station on the left. We can also see St Paul's Church before the spire was added.

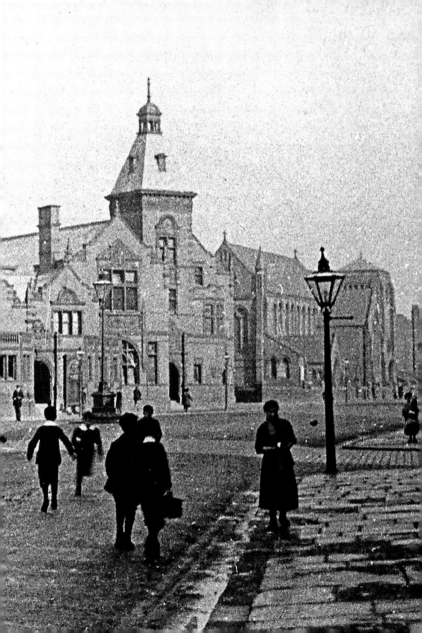

33. MOOR LANE BUS GARAGE

A view of the 'new' bus garage in Moor Lane taken in 1924. Moor Lane was a backwater at the time. Described as 'state of the art', the quote in the newspaper said, 'we're extremely proud of our elegant red-brick building with its fine terracotta detail'. Indeed it was a fine symbol of the town's pride. The building still stands today and the red brick has worn well.

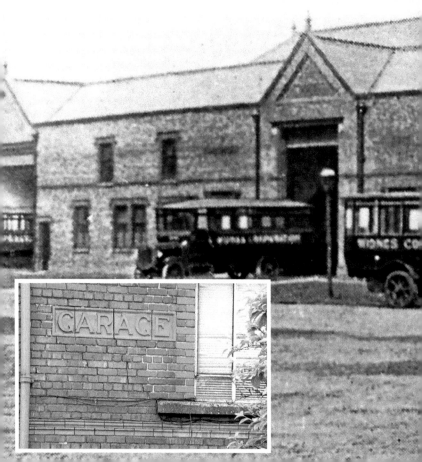

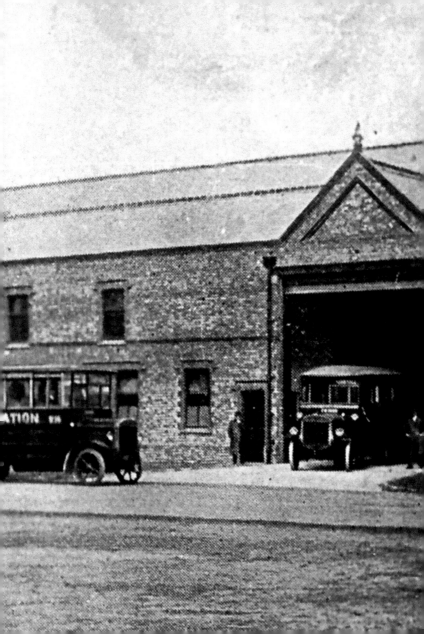

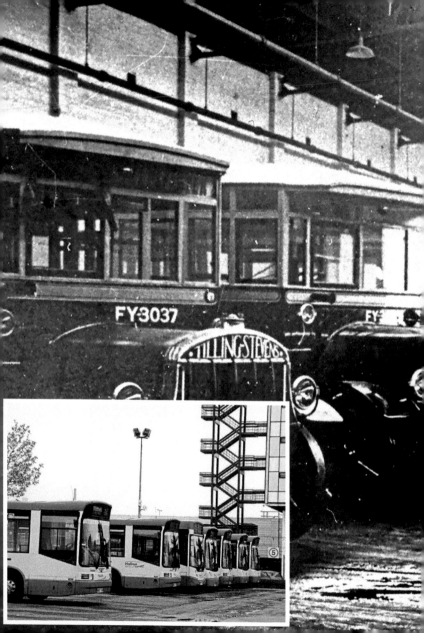

34. MOOR LANE BUSES

A grand display of Tilling Stevens buses lined up in the new garage. Today, unlike many areas, the bus company is still owned and run by the people of Halton. Here we see the fleet lined up behind the Municipal Buildings.

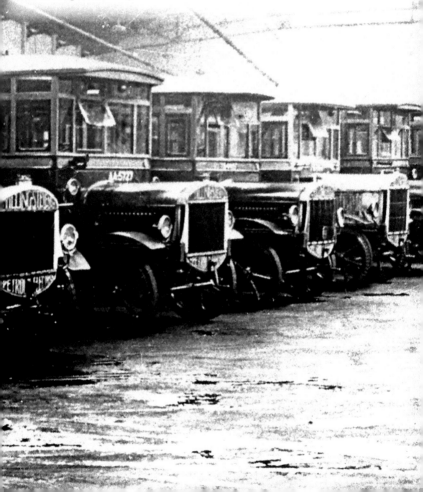

35. SUN INN, VICTORIA ROAD

Here people are proudly celebrating the coronation of Edward VII in 1902. Either a mural has been painted or a drape has been put on the side of the inn. On the left the barracks of the 47th Lancashire Rifle Volunteers can be seen, which later became the Black Cat Billiard Hall. The pub is now named Kelly's Bar. The name change was a reference to Ned Kelly as an Australian took over the licence.

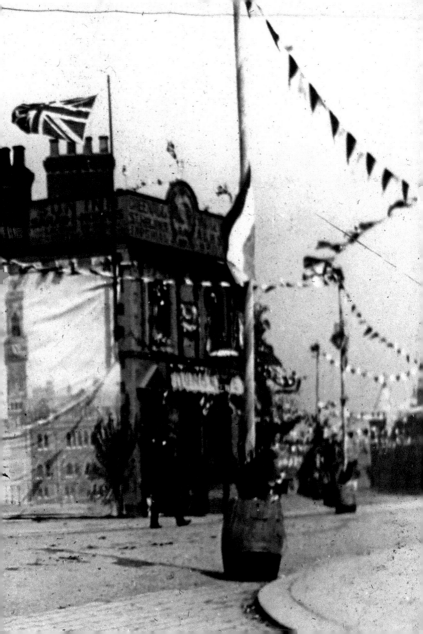

36. VICTORIA ROAD

Another shot of Victoria Road in 1902, with the Sun Inn in the background. This is a rare glass negative that accounts for the quality of the photograph. The boy in the foreground is taking a great interest in the photographer.

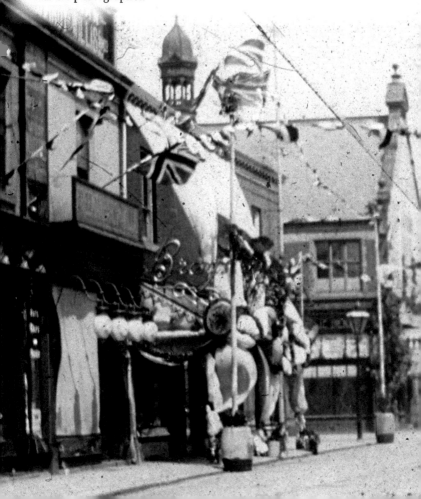

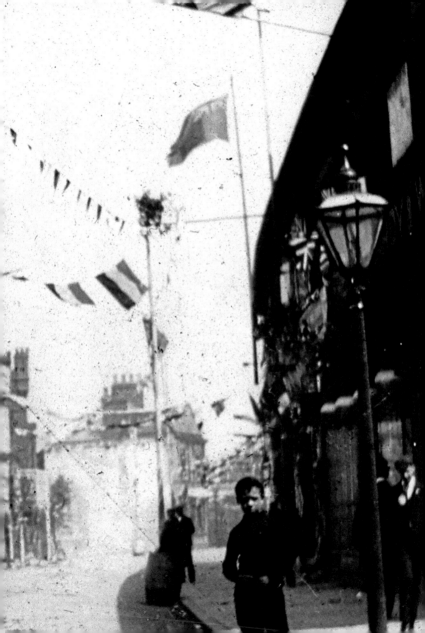

37. HUTCHINSON STREET LOOKING TOWARDS THOMAS BOLTON & SONS

The Mersey Copper Works were built in 1881 for smelting and electrolytic refining. The firm grew out of a business producing metal buckles into one of the world's leading wire, especially electrical wire, manufacturers. Bolton's were taken over by the cable companies in 1961.

38. WIDNES DOCK, SPIKE ISLAND

This was the birthplace of industry in Widnes. In 1847 John Hutchinson arrived from St Helen's aged twenty-two. He quickly saw the potential of this land and was able to purchase it for £12,000. The area was dominated by factories and a maze of railways crossed the island. In 1862, Ludwig Mond arrived in Widnes to inspect Hutchinson's work. John Brunner was the works manager. This was the start of the relationship that eventually became ICI. The land has since been reclaimed and we now have an important haven for wildlife, with the waterside being enjoyed by boating enthusiasts and day trippers.

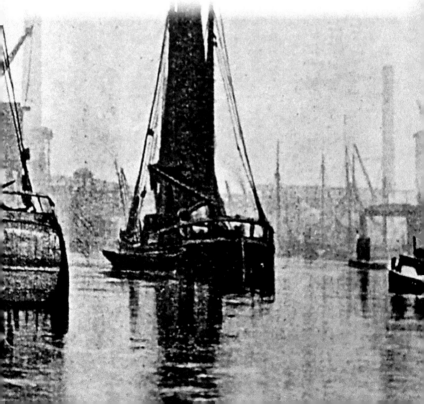

39. SPIKE ISLAND GOSSAGES

In 1850 William Gossage opened his works. He started to produce his soap, quickly making the luxury product affordable to everyone. Here we see the amount of industry thriving in West Bank. Today we see green spaces and the magnificent Catalyst Museum, opened in 1989 by Viscount Leverhulme. The tower was built by Hutchinson but became the head office of Gossage's soap works. Catalyst is a unique museum dedicated to the chemical industry and a great place to visit for adults and children alike.

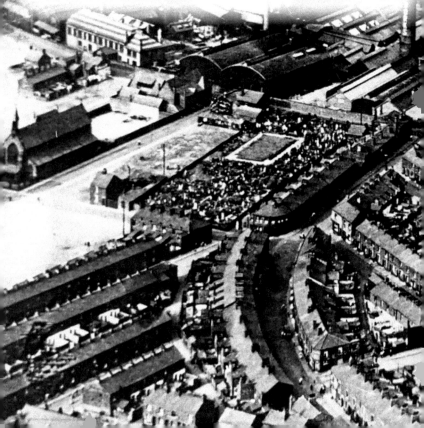

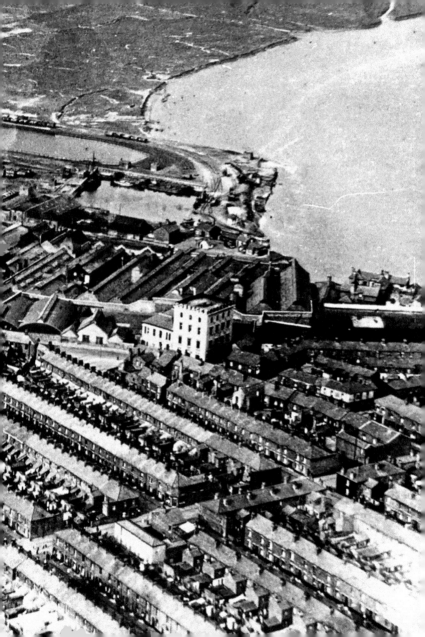

40. WEST BANK PROMENADE

In 1873 it was suggested that part of the flat grassed area on the riverside should be turned into a promenade. Five years later work started and was completed in 1884. This scene at dusk with the boats in the river has a romantic quality. Today boats are a rare sight in the river, although the promenade is still enjoyed by West Bankers.

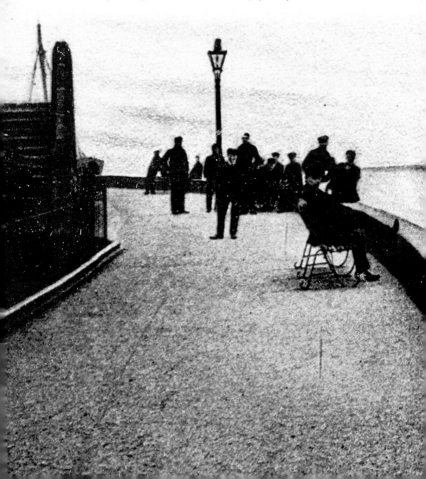

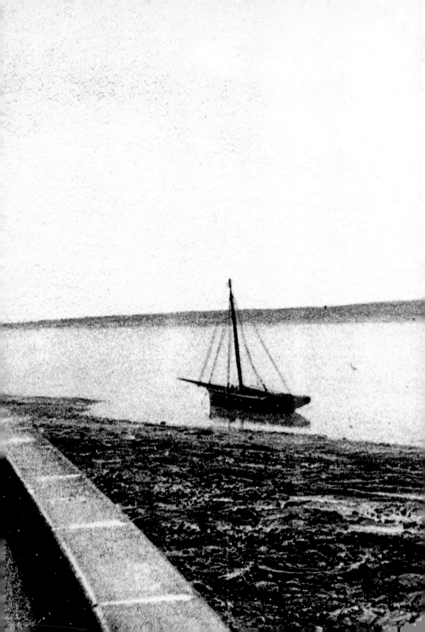

41. WEST BANK GARDENS

In 1903, the original promenade was extended and a bandstand was built to commemorate Queen Victoria. It was great place for relaxation and on Sunday evenings a band would play. A fête was also held every August. Families would go down to the beach to play games and enjoy sandcastle competitions. The ladies enjoying their cycling are dressed in their finest – no Lycra here. Sadly the transporter bridge is now long gone.

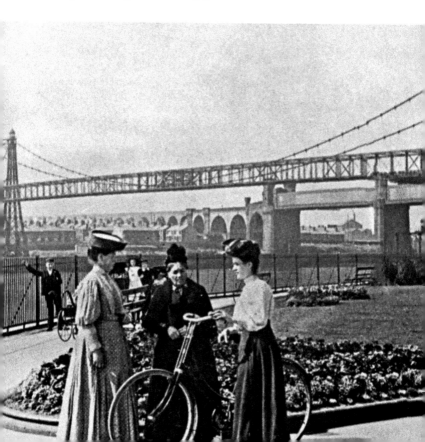

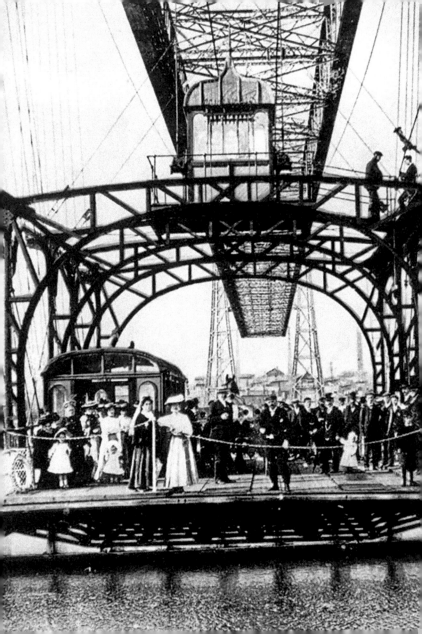

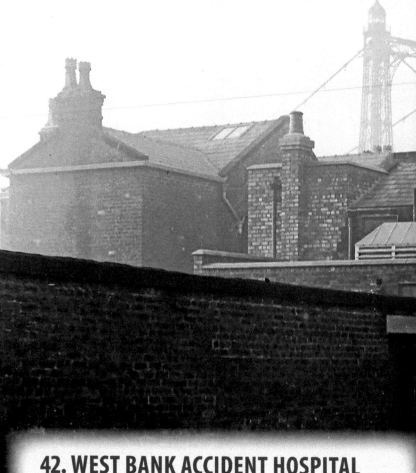

42. WEST BANK ACCIDENT HOSPITAL

The industry of West Bank must have resulted in many serious accidents but it was not until 1878 that Widnes had its own accident hospital. The building looks imposing but it provided excellent facilities. In its early days it provided only eight beds but was extended in 1914 to provide care for casualties of war. The hospital is now gone and just a red path shows the site.

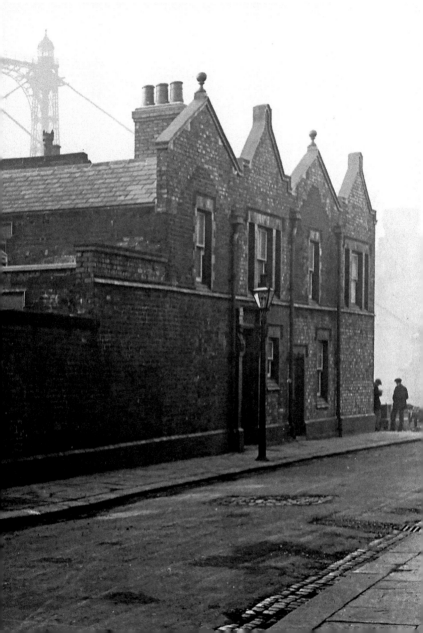

43. MERSEY ROAD, WEST BANK

A view up Mersey Road from the transporter bridge showing the Mersey Hotel. It was originally named the Boat House Inn as it was strategically placed for ferry travellers. In the 1930s the river was an important shrimping centre and the river would have been full of shrimp boats. The pub is still known locally as 'The Snig' as shrimp pie (snig) was a delicacy of the house. When the new road bridge was opened in 1961 it bypassed Mersey Road, with the once busy street becoming much quieter.

44. WELSH ARCH, IRWELL STREET

The Welsh Arch was built to celebrate the coronation of Edward VII in 1902 when West Bank was a thriving busy community. This is the corner of Irwell Street. We see the strength of the Welsh community in West Bank and the sign reads 'Best Wishes To Your Reign'. The terraces still stand today and have been lovingly updated.

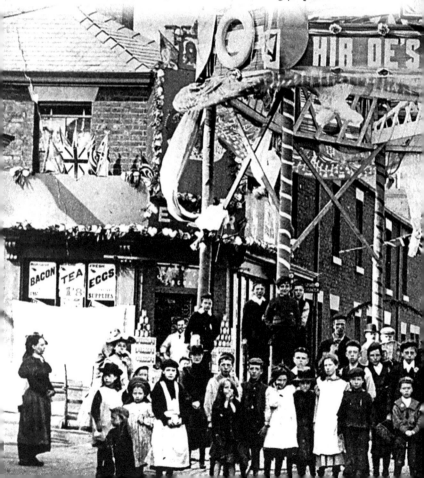

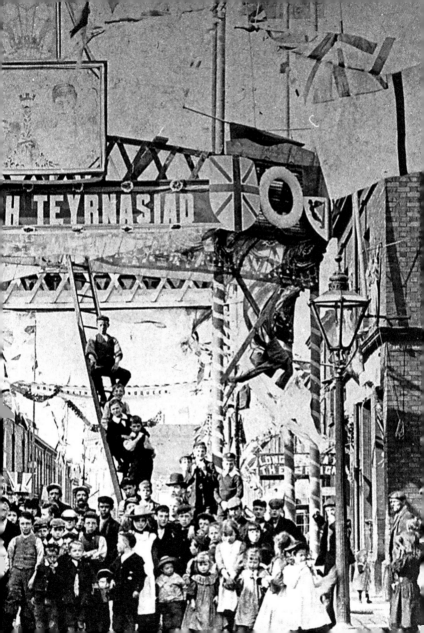

45. WEST BANK HOTEL

The West Bank Hotel was known as 'The Vaults' to West Bankers. Here the staff are proudly lined up outside this impressive hotel. It was built in 1864 by John Gerrard. In 1938, despite its fine appearance, it was considered so dilapidated that it should be closed. Happily it was reprieved and the building has now been transformed into flats.

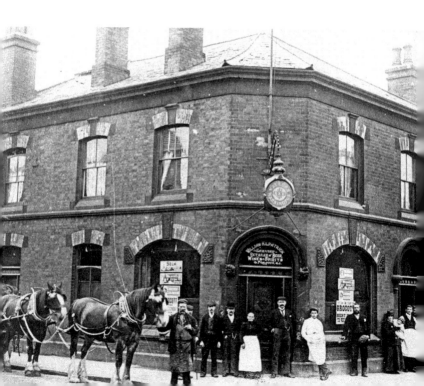